Rocks

ROCKS

Franklin Carmichael, Arthur Lismer, and the Group of Seven

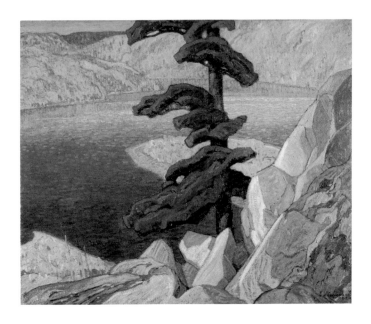

Joan Murray

McArthur & Company

Toronto

Published in Canada in 2006 by
McArthur & Company
322 King Street West, Suite 402
Toronto, Ontario
M5V 1J2
www.mcarthur-co.com

Library and Archives Canada Cataloguing in Publication

Murray, Joan
 Rocks : Franklin Carmichael, Arthur Lismer, and the Group of Seven / Joan Murray.

ISBN 1-55278-616-1

 1. Carmichael, Franklin, 1890–1945 – Criticism and interpretation.
2. Lismer, Arthur, 1885–1969 – Criticism and interpretation.
3. Group of Seven (Group of artists). 4. Rocks – In art. I. Title.

ND245.5.G7M885 2006 704.9'49552 C2006-905552-1

Front jacket photograph: *Bay of Islands from Mt. Burke, 1931,* McMichael Canadian Arts
 Collection, Kleinburg
Back jacket photograph: *Cathedral Mountain, 1928,* Montreal Museum of Fine Arts
Title page photograph: *The Upper Ottawa, Near Mattawa, 1924,* National Gallery of
 Canada, Ottawa

Design and composition by Counterpunch
Printed in Canada by Friesens

The publisher would like to acknowledge the financial support of the Government of Canada through the Book Publishing Industry Development Program, the Canada Council, and the Ontario Arts Council for our publishing activities. We also acknowledge the Government of Ontario through the Ontario Media Development Corporation Ontario Book Initiative.

10 9 8 7 6 5 4 3 2 1

"Mountains don't bend in the wind ..."

Arthur Lismer in an interview with Dr. Evan Turner, Montreal Museum of Fine Arts, no date (1977?), Library and Archives Canada, Gatineau, J. Russell Harper fonds, volume 28, file 19.

CONTENTS

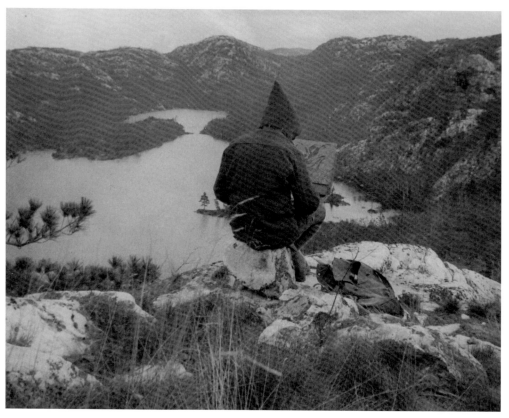

Franklin Carmichael sketching at Grace Lake, Ontario, October 1935

An Everlasting Beauty

They are Canada's great heroes, the Group of Seven, surviving Europe and then surviving Canada when they came back. Knowledgeable in styles studied abroad, they returned to a country that was still considered partially a wilderness. They made this landscape the public expression of spiritual values, having perceived the unique qualities of the country's natural environment.

Their success meant they had to travel across the country to discover its characteristic look. To paint as they did, they needed moral earnestness. Their way of painting was to be grander, nobler. "Don't niggle," A.Y. Jackson, one of the members, told a student, using a word, forgotten now, that suggests a finicky handling. J.E.H. MacDonald, another member, told others, "Think big, be generous, don't fiddle, enlarge yourselves."

Monumentality of a kind, they certainly achieved. The scenes in their paintings do indeed look thrilling: the light bursting through the clouds in Algonquin Park, the stunted pines whipped by the wind in Georgian Bay, and among the most important features of their art – the rock. Tom Thomson and the Group of Seven loved to paint the Precambrian Shield – rock that is an extensive structural unit of the Earth's crust formed during several rounds of mountain-building activity. After years of erosion, what remains today is a low, rolling plain, rock strewn with countless bodies of water, rock that affects Canadian history, rock that hides great treasure in precious metals, rock with its everlasting beauty.

This ancient rock was part of the thematic content of the paintings of the Group of Seven from the very beginning. Already in 1913, A.Y. Jackson's *Terre Sauvage*, with its northern landscape subject matter (Jackson made the studies in Georgian Bay), bold handling, and strong colour, celebrated the permanent splendour of the rocky shield. The first

large canvas of the movement, this painting was the quintessential expression of what was in store for the Group. Jackson emphasized the slope of the hills, their extension into the background, and the way the individualistic trees and scrub vegetation fitted into the rocky "savage land."

Jackson wrote in his autobiography, *A Painter's Country*, that J.E.H. MacDonald nicknamed the work "Mount Ararat," because the scene looked like the first land that appeared after the Flood subsided. Indeed, with its optimism, burgeoning energy, and explosive power, the canvas does have an apocalyptic quality. It expresses in bold characters what would come to be seen as the opening lines of the first chapter in Canadian art history of the twentieth century.

Thomson and the Group of Seven seriously gazed at rock. "Rock Watching" it is called by those who celebrate the natural beauty of sedimentary deposits. In time, the aesthetic gratification that Thomson and the Group received from painting the rock contributed to their generous imagination of the country; some of them even mined the subject in greater and greater explorations. Arthur Lismer found in rock the lord of the land, and painted it with delight, relishing its massive shapes and bigness. Frank Carmichael used the La Cloche Mountain range as his special subject in elegant paintings and watercolours in which the white quartzite rock sometimes seems to reflect the light – as it does in the La Cloche itself. Lawren Harris and A.Y. Jackson demonstrated how to concoct powerful and decorative paintings in which rock ranges from streamlined buoyancy, so that it looks light and pliable, to a raw density, reinforced by build-ups of painterly impasto. All these artists saw the land of which the rockface was a part as a conduit to profound emotional or spiritual enlightenment. Their work varied from panoramic views to efforts at using the framing effects that rock can provide. Often their work offers a sense of the rugged, stark qualities of rock: theirs is a record of natural geography and even more than the pines they painted, rock is a symbol

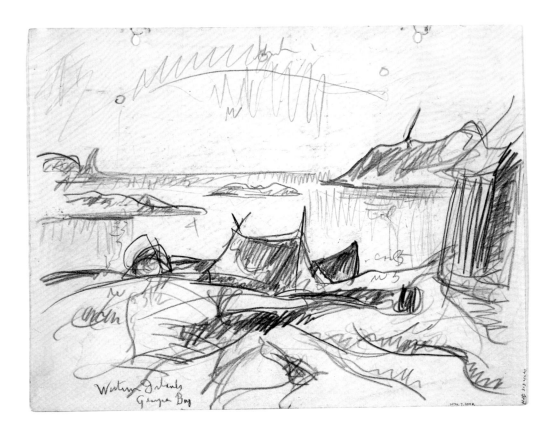

A.Y. Jackson

Graphite on paper, 22.9 x 30.5 cm

McMichael Canadian Art Collection, Kleinburg (1974.7.104.R)

Gift of the artist, Kleinburg, 1974

Courtesy of the Estate of the late Dr. Naomi Jackson Groves

Rocks and Water, Georgian Bay, date unknown

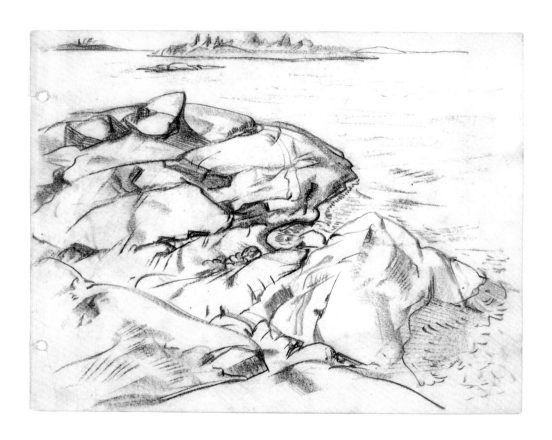

Arthur Lismer
Conté and graphite on paper, 22.7 x 30.2 cm
McMichael Canadian Art Collection, Kleinburg (1981.190.32)

Rock Formation, Georgian Bay, 1926

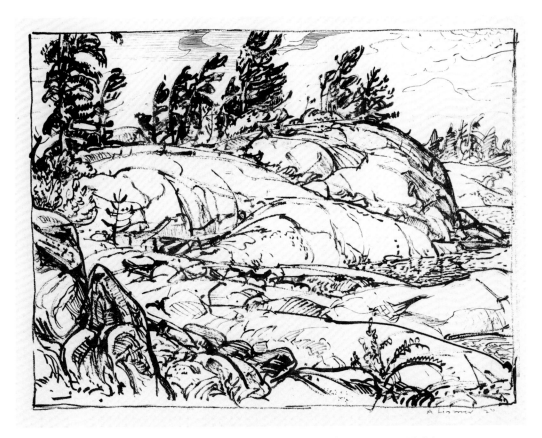

Lismer loved the contrast of the strong rock formations of Georgian Bay with their elephantine shapes and the flowing water, and he sketched and painted them often.

Arthur Lismer
Ink on paper, 27.9 x 38.1 cm
Art Gallery of Ontario, Toronto (2315)
Gift from Friends of Canadian Art Fund, 1935

ROCKS AND STREAM, 1909

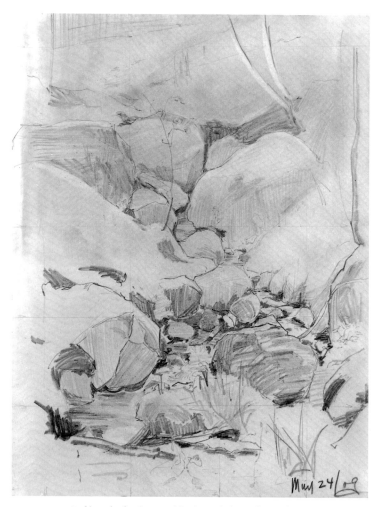

In this early sketch, Carmichael reveals his preference for the powerful pattern rocks make at either side of a quiet stream.

Franklin Carmichael

Graphite on paper, 27.9 x 21.0 cm

McMichael Canadian Art Collection, Kleinburg (1976.25.7)

Gift of the Founders, Robert and Signe McMichael, 1976

of longevity. Every stone in their work is artfully placed with attention to texture, form, shadow, and contour.

Looking at these paintings offers us a series of views, one which makes cities seem distant. Through these works, we too can understand the way in which rock can inspire the contemplative spirit. The act of painting it must surely have been meditative, particularly for those who fell in love with the subject, such as Lismer, who in painting Georgian Bay found in rock the perfect contrast to more ephemeral weather and vegetation. Carmichael, too, perched high on the rock of the La Cloche region of Georgian Bay in the days of the late summer and autumn, reflected on the glory of the subject. Some of their paintings conjure up memory and history as if in an ancient light. But the drifting clouds are a reminder to savour the passing beauty of the present.

"Georgian Bay!" wrote Arthur Lismer, as reported by his daughter, Marjorie Lismer Bridges, in her book *A Border of Beauty* (1977), "Thousands of islands, little and big, some of them mere rocks just breaking the surface of the waters of the Bay – others with great, high rocks tumbled in confused masses and crowned with leaning pines. ... It is a paradise for painters." Lismer's Georgian Bay had fascinating rocks, each modelled on different powerful forms, embellished with pines, little pools of water, and flowers.

One of Lismer's most intriguing rock subjects is his painting *Rock, Pine and Sunlight* (p. 81). Its entire surface seems animated because Lismer painted the vegetation in the foreground and the water in the middle ground with scintillating brushstrokes while he boldly simplified the masses of the rock in the background so that it assumed a robust, earthy palpability. In his *Cathedral Mountain* (p. 87), which he painted in a boldly expressionistic style, characterized by energetic brushwork, simplified form, and strong design, the mountain struck him as something like a "great big Gothic structure," as he told Dr. Evan Turner of the Montreal Museum of Fine Arts (see

the interview in the Appendix): "there were the buttresses and the pillars, towers, and supporting weights like a vast piece of architecture." Lismer continued, comparing the mountain to the architecture and spiritual nature of a church. The people responsible for the names Temple Mountain, Castle Mountain, Cathedral Mountain, he believed, were reminded of something in the edifices of the Church throughout history. He painted it that way, more vertical than it is in reality, with its tops touching the clouds. For him, Cathedral Mountain was an "almighty paean of praise."

But, more than that, Cathedral Mountain and all the mountains and rocks of Canada, as well as the challenge of its landscape, excited him by their newness. To stand in this great land helped him know his place in the world and the feeling contributed to the vigour of his paintings. Lismer was an Englishman by birth, born and raised in England's northern industrial city of Sheffield, and he had studied at the Sheffield School of Art (1899–1906) and in Belgium at the Royal Academy of Fine Arts in Antwerp (1906–07) before immigrating to Canada in 1911. The awesome beauty of his newfound land gave him a fresh perspective. It was this quality, he believed, that created the Group of Seven, of which he was a founding member. In his conversation with Dr. Turner, he describes his working method: Lismer believed that in making art he had to reduce the forms he saw away from the usual topographical photographs that were found in advertising brochures and try to develop design out of it. As he said, "And you began to … see a rhythm that united sky and land in a great rhythm, and it was challenging. When you got back to your studio as a matter of composing it into, well, composing yourself and it into some kind of canvas that brought out those particular attributes."

In thinking his way into his creative place in the world, Lismer developed strategies, ways of inviting the viewer's eye to follow his activities on canvas, his almost Cubist handling of form, for instance, his loose and electric drawing, combined with his unusual touches of colour. Rock

GEORGIAN BAY ROCK, 1952

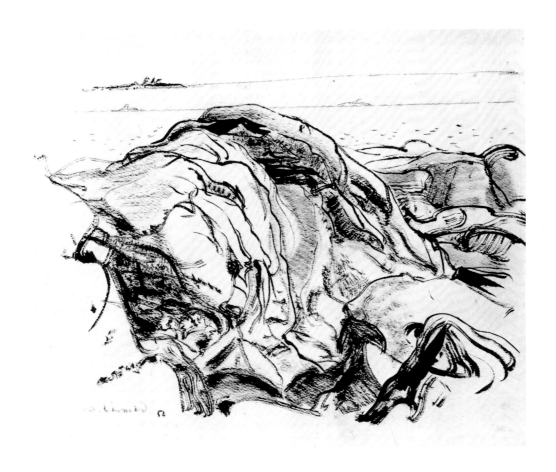

Arthur Lismer

Ink on paper, 37.5 x 45.2 cm

National Gallery of Canada, Ottawa (6622)

Purchased, 1956

Arthur Lismer, c. 1926

became for him one of his tools in this process, framing a scene or leading the viewer's eye into the distance, or even, as with *Cathedral Mountain*, the subject of a great painting.

Carmichael was similar to Lismer in that he was an artist who knew how to entice the viewer into a landscape, but even more than Lismer, under Carmichael's brush, his vast images of rolling, rocky hills, a subject he often painted during the late 1920s and the 1930s, appear at their most sublime. As the youngest among the founders of the Group of Seven, and its junior member, at least until A.J. Casson was invited to join the Group in 1926, Carmichael had something to prove. His richly colourful, sturdy vision of Canada in which he used the painterly rhetoric of the Group made him a worthy associate, but for him, the burning question was how to create work that was different from anyone else. Over time, he achieved this aim in two ways: in terms of technique, he developed the use of the watercolour medium (in 1925, he became one of the founders of the Canadian Society of Painters in Water Colour with Casson and F.H. Brigden), and through the La Cloche Mountains, he discovered *his* special subject.

The barren scenery of the La Cloche was particularly important to him. Not only did the elevations of the white quartzite mountains and pink granite hills, with their stunted vegetation overlooking sapphire lakes, offer spectacular views, but the subject also showed him how to become a quintessential painter of time and even of the spiritual in landscape. His paintings of the rents in the clouds make him the great recorder of the changing moment, especially the ephemeral in terms of light and weather.

Carmichael probably first visited the La Cloche region on the north shore of Georgian Bay in 1924, but he soon found the scene of the imposing mountains, deep lakes, and ensembles of islands trailing into the distance completely engrossing. Because of forest fires, parts of the rock formations were highly visible at the time of his first visits and the colour contrasts sharper, more so than today. He loved the comprehensive view

Franklin Carmichael, 1930

National Gallery of Canada, Ottawa

he found from climbing to high vantage points, especially the subtle effects of light playing on the rolling hills. In the La Cloche, he realized he had found the subject that would be the foundation to his life's work. The rock offered him something big, something original – a way of not replacing daylight's vision but extending it to show the power of nature.

Carmichael's daughter, Mary Carmichael Mastin, writes of his decision to make the La Cloche Mountains an integral part of his personal life and his artistic career in her essay "The La Cloche Decision" in *Light & Shadow: The Work of Franklin Carmichael* (1990). She describes the geographic placement of this unique landscape along the north shore of Lake Huron, extending west from Killarney Provincial Park, and the way in which three mountainous fingers converge into high, barren ridges, deep, forested gullies, and long, narrow lakes of ethereal clarity – subjects painted by Carmichael.

Geographically, the land was once part of the Canadian Shield, but about two billion years after the creation of the primeval seas, the rock began to rise and culminated in a massive range of white mountains. These rocks, as Carmichael was intrigued to find, cause a striking shift of light and, together with the constantly changing weather pattern, provide a challenge to any artist. In 1935, after years of camping and the most modest accommodation, Carmichael made a big commitment – he built a log cabin on Cranberry Lake for himself and his family. It became the starting point for many camping and painting expeditions and helped to keep the La Cloche Carmichael's constant source of inspiration until his death in 1945.

Carmichael's art career shares an affinity with other members of the Group of Seven. He was a landscape painter, along with Harris, Lismer, Jackson, and the others. Like many of them, he worked at the ambitious Toronto firm of Grip Ltd. and then in 1912 he moved to the firm of Rous and Mann. Likely because of the endorsement of two artists with whom he worked – Lismer and F.H. Varley, both of whom already had studied

Franklin Carmichael

Graphite and charcoal on paper, 28.6 x 22.3 cm

National Gallery of Canada, Ottawa (39334.12)

Gift of Mary and Richard Mastin, Toronto, 1997

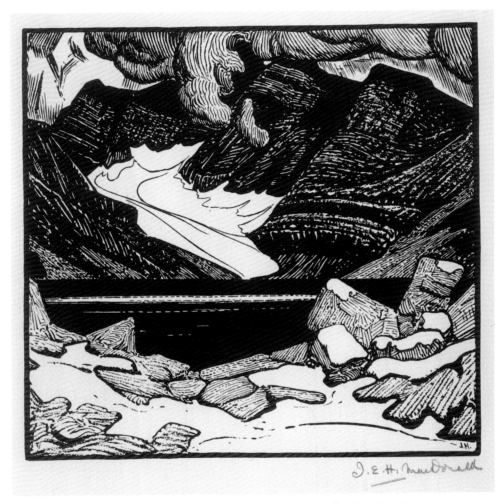

In his few prints, MacDonald extracted broad and inventive effects from the medium:
here he used strong design to create larger forms, with results reminiscent of sculpture.

J.E.H. MacDonald

Lithograph on paper, 38.6 x 28.4 cm

McMichael Canadian Art Collection, Kleinburg (1981.229.15)

Rocky Mountains, 1924

Lawren Harris
Ink on paper, 35.1 x 39.3 cm
National Gallery of Canada, Ottawa (3169)
Purchased, 1925

in Antwerp at the Academy – Carmichael studied at that school from 1913 to 1914. What he learned was basic academic procedure, drawing from the cast and the model. He seems, too, to have been encouraged to sketch out-of-doors.

On his return to Canada in 1914, he took up residence in the Studio Building in Toronto, and in December shared a studio with Tom Thomson. With encouragement from Thomson and other artist peers or perhaps because of his own competitive spirit, his work as a painter at last came together. He began to record that winter in a small number of outdoor sketches. He seems to have used one of these tiny panels towards one of his first major paintings, *A Muskoka Road*, of a snowy scene in the North, a breakthrough in his work towards broad handling and bold brushwork. Through the years, he inclined towards landscape subjects that offered a sense of mood. By 1920, with the founding of the Group of Seven, his work reveals that he sought an effect of rich colour and design. He was, at the time, in the best sense of the word, a decorative artist.

In works such as *Autumn Hillside* of 1920, Carmichael featured the pictorial motif that was to become such a feature of his later work. A bank of cloud (here lavender) lifts like a curtain to reveal, in the distance, clear sky and rolling hills: we have the promise, it seems, of clear weather. In the painting, Carmichael ably handled colour and composition. In the immediate foreground, partly shadowed, appear a tree stump and dark grey and brown rocks (where the light falls on them the rocks turn into a medley of pink, cream, and purple); in the middle ground stand dark green pines; and in the background, we find white birches with their brightly lit gold, yellow, and cream fall foliage. In the far distance of the canvas, Carmichael painted what look like two different skies, one farther back indicating fine weather.

Through the 1920s, Carmichael matured as an artist, developing more elegant colour effects, broader handling, and a greater emphasis on three-dimensional form. His was an exploration of nature that was only to

intensify. By 1924, in paintings like *The Upper Ottawa, Near Mattawa* (title page and p. 32), he had discovered the rugged qualities that rocks with their powerful, massive shapes and geometric surfaces can add to a scene of a single tree, water, and high hills. Now we find the viewpoint from a height that gave him the sense of the vantage point he favoured in many of his later works along with the emphasis on time and weather – here autumn, and a bright day of strong sun and deep shadow. Soon, for Carmichael, the contours of rocky hills became a normal way of grounding a scene.

One of the crucial individuals who changed Carmichael's way of looking at art, and whose example intensified the sculptural quality to his forms and simplified his organization, was his friend and mentor Lawren Harris. Around 1924, Harris was achieving feats of picture-making in paintings such as *Above Lake Superior* where, with a sure grip on pictorial structure, he transformed the forms of nature into lucid design. In these and similar paintings Harris reduced the shapes of mountains, shoreline, trees, lakes, and clouds to their essentials for distant monumental effect. Harris had first gone to the north shore of Lake Superior with A.Y. Jackson in 1921 and quickly realized that he had found his perfect painting country. It fulfilled his desires for a simplified pared-down land with grandeur and vista.

In 1925, and again in 1926 and 1928, Harris invited Carmichael to join him on the fall sketching trips he liked to make to Lake Superior, along with fellow Group members like Jackson and in 1928, Casson. Such trips would have brought Carmichael close to Harris and to Harris's increasing involvement with theosophy, a system of belief in the attainment of knowledge of God by mystical intuition or occult revelation. In 1926, Harris published his powerful article "Revelation of Art in Canada," which appeared in the *Canadian Theosophist*. In one section, Harris thundered about the great North "and its living whiteness, its loneliness and replenishment, its resignations and release, its call and answer – its cleansing rhythms." He wrote of the art that could be made by Canadians – "an art

ROCK STUDY

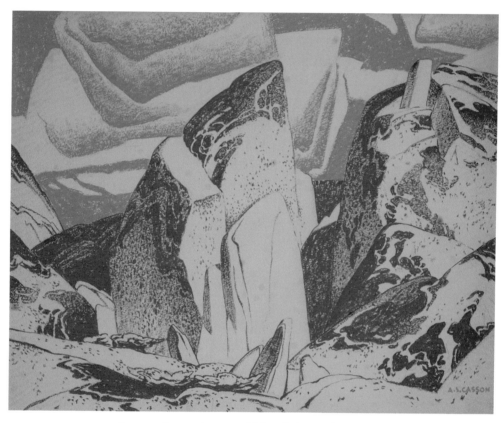

*Casson made many tiny pen-and-ink wash sketches of rock using a
Cubist complexity of form as ideas for later paintings.*

A.J. Casson
Ink on paper, 28.0 x 34.3 cm
Museum London, London, Ontario (80.A.105)
Gift of Mr. and Mrs. John H. Moore, London, Ontario,
through the Ontario Heritage Foundation, 1980

Rocks, 1943

Lionel LeMoine FitzGerald
Chalk on paper, 58.9 x 41.9 cm
National Gallery of Canada, Ottawa (16342)
Gift from the Douglas M. Duncan Collection, 1970

more spacious, of a greater living quiet, perhaps of a more certain conviction of eternal values." He concluded this extraordinary paragraph by writing, "We were not placed between the Southern teeming of men and the ample, replenishing North for nothing."

Harris's words were inspiring, and he was as a man, charismatic. Carmichael would have respected his strong vision, and the way Harris had resolved to focus more on "the great North" and the spiritual aspects of a scene. But Carmichael was his own person and artist. His views on the spiritual were not limited to theosophy, but spread over a much wider range – he was always thinking and reading, particularly Ralph Waldo Emerson, but many other books too, as his granddaughter, curator Catharine Mastin, suggests in *Portrait of a Spiritualist* (2001) (she reproduced a list of books from his library that are today in the archives of the National Gallery of Canada). It was his own vision Carmichael brought to bear on the scenery before him, sometimes using the medium of watercolour, by contrast to Harris who used oil paint, to record the changing weathers and the light. That Carmichael used this medium is a signal of the rapid development of his own beliefs.

Yet through the company of Harris and the trip to Lake Superior, Carmichael developed what would be in essence his own way of comprehending the land. *Snow Clouds* (p. 35), developed from a sketch painted in Lake Superior on Carmichael's 1925 trip, shows us what would be his approach in paint to the La Cloche. The rocks are interpreted in a series of massive green and brown forms, turned pink and white with blue shadows in one area by the light; in the sky huge clouds form lift to reveal in the distance the paler blue of clear sky and water.

The La Cloche meant to Carmichael an intensification of these effects, whether of luminescent effect in the distant light breaking through the clouds or remarkable rockscape, trees, and vegetation. Often he evoked a beautiful balance of dark and light, surely as an expression of the larger

This drawing is a study for a painting by Casson, Rock Cluster, Madawaska River, *of 1963. On the verso is an explanation of the title, part of which reads "Idea/[a series of doodles]/Built as music/3 dimensional-colour-Line-Mass-Tone." Casson was here creating a riff on the theme of rock.*

A.J. Casson

Graphite on paper, 20.4 x 27.5 cm

McMichael Canadian Art Collection, Kleinburg (1966.16.132)

Gift of the Founders, Robert and Signe McMichael, Kleinburg, 1966

spiritual narrative in which he believed. But from an early date he also evoked industrial production in the North and its effect on the pristine land. Paintings such as *The Nickel Belt* (p. 39), while magical, raise environmental issues. Smoke billows away from the land into the clouds and in the foreground looms the barren rockscape. The threat was there for all to see and for a later generation to try to correct. Carmichael's art traced the options, but it was his rich and fertile vision of the La Cloche Mountains that gave his art a new potential and in time, its main excitement. On gallery walls, these paintings exert a powerful resonance. They almost turn into religious icons, symbolic condensations of the ultimate values of lucidity to which all members of the Group of Seven subscribed, but to which few artists today can pledge undivided allegiance.

Carmichael had a lifelong fascination with the rockscape.

Franklin Carmichael

Charcoal on paper, 28.6 x 22.3 cm

National Gallery of Canada, Ottawa (39334.10)

Gift of Mary and Richard Mastin, Toronto, 1997

The Rocks

This book celebrates the landforms of Canada, individual units of a landscape created by the interaction of climate with rocks on the Earth's surface. River erosion has also played its part.

The fundamental basis of Canada, the bedrock structures beneath the surface, is enormously old. So are the mountain systems, the major plateaus, and of course the Canadian Shield, one of the oldest, most rigid, and most permanent elements in the earth's surface, as J. Brian Bird writes in his introduction to *The Natural Landscapes of Canada* (1980). The Group of Seven sought to make Canadians more aware of the diversity of these ancient rocks. Knowledge of the land, they believed, was crucial to an understanding of Canada.

With the great crisis in world climate approaching, it is timely to reflect on the character of Canada's natural landscape and to look again to our great artists and their vision of the land.

LIST OF PLATES

ROCKS

Franklin Carmichael, 1890–1945

Autumn Foliage against Grey Rock, c. 1920

Franklin Carmichael's interests lay beyond mere picturesque representation; in his paintings he enjoyed capturing contrast, combining bare tree trunks with vividly coloured foliage, or as here, brightening a scene of a rocky landscape with a burst of colour from a fall tree and a pink and green sky.

Franklin Carmichael
Oil on wood-pulp board, 25.2 x 30.6 cm
National Gallery of Canada, Ottawa (38405)
Gift of Mary Mastin, Toronto, 1996

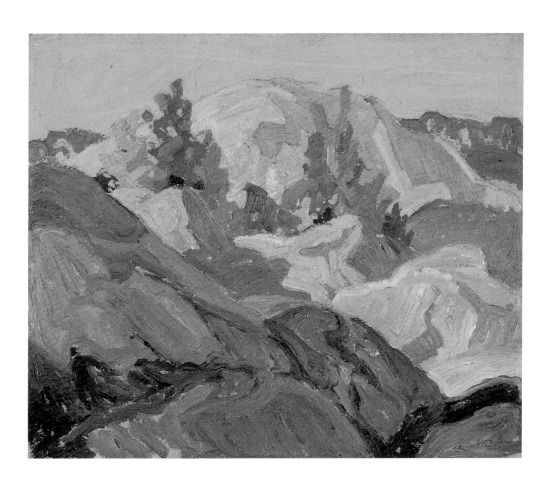

THE UPPER OTTAWA, NEAR MATTAWA, 1924

Through the 1920s, Carmichael matured as an artist, developing more elegant colour effects, broader handling, and a greater emphasis on three-dimensional form. His quest was to give visual form to the pleasure he took in his exploration of nature. By 1924, in paintings like *The Upper Ottawa, Near Mattawa*, the painting by which Carmichael is best known, he had discovered the rugged qualities that rocks with their powerful, massive shapes and geometric surfaces can add to a scene of a single tree, water, and high hills. Now we find the viewpoint from a height that gave him the sense of the vantage point he favoured in many of his later works along with the emphasis on time and weather – here autumn, and a bright day of strong sun and deep shadow.

Franklin Carmichael
Oil on canvas, 101.5 x 123.1 cm
National Gallery of Canada, Ottawa (4271)
Purchased, 1971

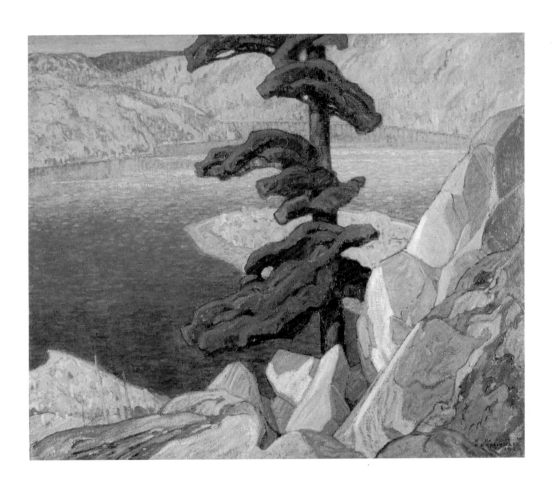

SNOW CLOUDS, 1926

Carmichael was an engaged, passionate landscape painter with a classicist's emotional tact, a reticent Canadian. Rocks, hills, and mountains were part of his observation of his surroundings and he conveyed in his paintings his susceptibility to their colour and rough texture.

Franklin Carmichael
Oil on canvas, 101.5 x 122.5 cm
Hart House Permanent Collection, University of Toronto

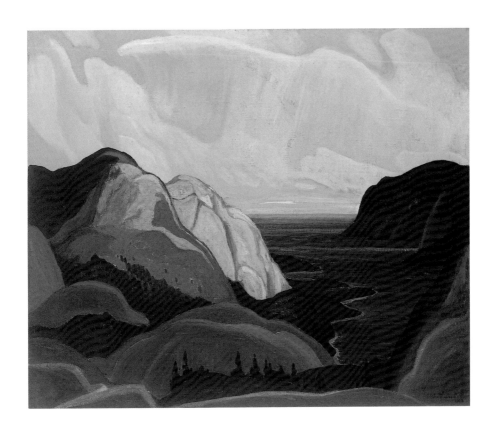

North Shore, Lake Superior, 1927

As curator Catharine Mastin, Carmichael's granddaughter, points out in *Portrait of a Spiritualist* (2001), Carmichael's library offers insight into his search to understand spiritual values: he owned Ralph Waldo Emerson's *Essays and Other Writings* and many other books that expressed his interest in a higher order than a material one.

When he brought home work from Lake Superior, friends such as artist Bertram Brooker were quick to recognize the spiritual dimension to his new creative endeavour. Carmichael had made significant changes in style, simplifying and using colour more boldly to create formally more ambitious work.

Franklin Carmichael

Oil on canvas, 102.8 x 122.5 cm

Art Gallery of Ontario, Toronto (91/33)

Purchase with the assistance of the Government of Canada

through the *Cultural Property Export and Import Act*, 1991

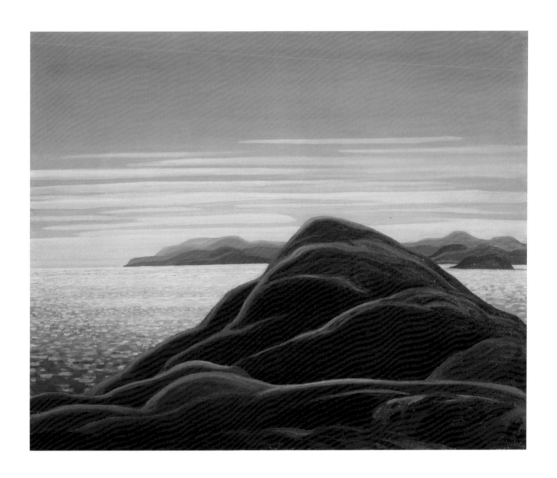

THE NICKEL BELT, 1928

Carmichael's complicated and often haunting landscapes verge on the abstract. One of the works in which he expressed his view of nature and industry is *The Nickel Belt*, but it also is about space and beauty: how to choreograph the movement of the clouds and express the shapes of the rocks. Although wary of the ugly effects on the environment of acid rain, he painted the nickel belt with a kind of transcendent power.

Franklin Carmichael
Oil on canvas, 101.8 x 122.0 cm
Firestone Art Collection, The Ottawa Art Gallery (FAC0108)
Donated by the Ontario Heritage Foundation to the City of Ottawa

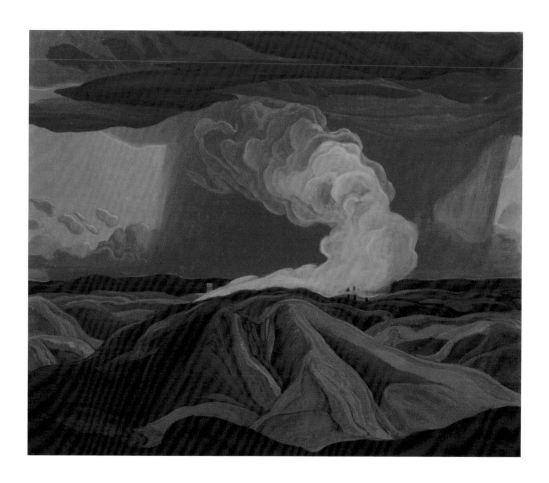

LAKE WABAGISHIK, 1928

One of Franklin Carmichael's favourite painting places was the spectacular La Cloche Mountains of Ontario. The ancient formations of the white quartzite rocks, the vast stretches of water, the scrub vegetation and stunted trees, became part of his formal vocabulary in paint from the early 1920s to his death in 1945. Mary Carmichael Mastin wrote glowingly of the area's "humped contours" in an essay titled "The La Cloche Decision" in *Light & Shadow: The Work of Franklin Carmichael*, Carmichael's retrospective catalogue by Megan Bice (1990). Mastin describes the history of the La Cloche area and Carmichael's affinity for it which prompted his decision to build a log cabin there (1934–35).

As Bice writes, *Lake Wabagishik* is the first canvas Carmichael painted in the La Cloche Mountains in which there is no evidence of human presence. His vision of the sky is punctuated by a storm: rain falls on distant blue hills and the water and trees seem blown by the wind. The painting exudes a forceful presence.

Franklin Carmichael
Oil on canvas, 101.5 x 122.0 cm
McMichael Canadian Art Collection, Kleinburg (1976.11)
Gift of Shulton of Canada Ltd., Scarborough, 1976

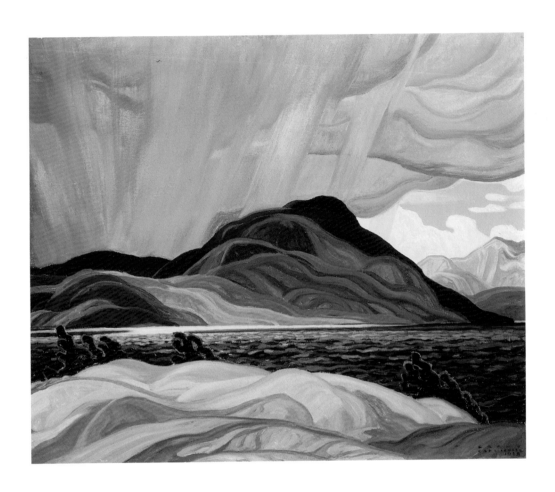

Bay of Islands from Mt. Burke, 1931

Bay of Islands, with its panoramic view from Mt. Burke, its strong delineation of the hills and the islands that extend into the distance, suggests Carmichael's delight in the area. Notice the way Carmichael has adroitly orchestrated a burst of light to illuminate a section of the foreground revealing patches of green, brown, gold, and orange where vegetation covers a nearby hill.

Franklin Carmichael

Oil on canvas, 101.6 x 122.0 cm

McMichael Canadian Art Collection, Kleinburg (1975.62)

Gift of Mr. and Mrs. R.G. Mastin, Willowdale, 1975

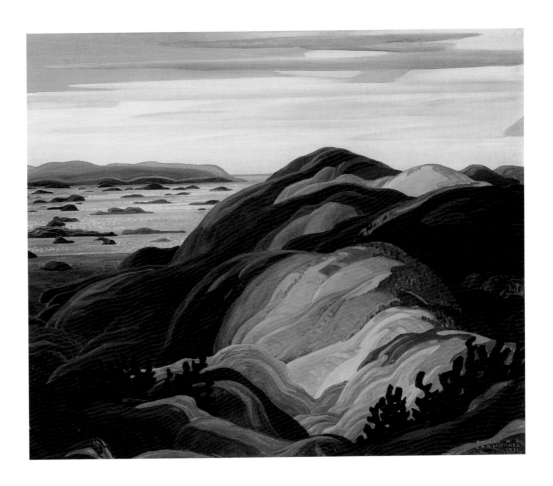

Snow Clouds, 1938

Carmichael developed a powerful body of work to strengthen Canadian awareness of the beauty of the La Cloche area of Ontario. His was an inspired personal vision of the landscape in its many different moods and weathers. Here he conveys a moody tension between the soon-to-come snow and the vast ranging land. The result has both palpability and other-worldly dreaminess.

Franklin Carmichael

Oil on Masonite, 96.0 x 121.4 cm

National Gallery of Canada, Ottawa (4549)

Royal Canadian Academy Diploma work, deposited 1939 from the artist

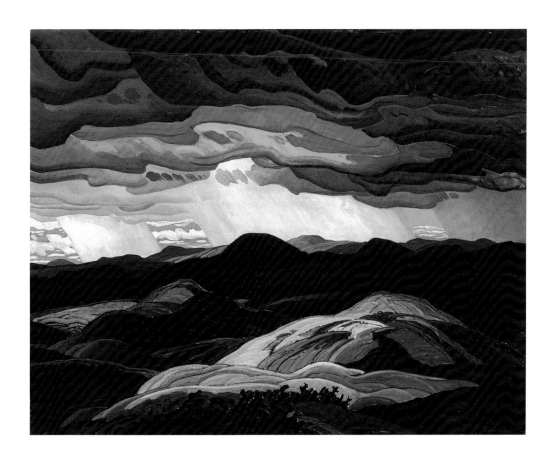

Autumn, 1940

Painting the same area over a period of years can be an intense experience. Carmichael trained the same compassionate eye on the landscape of the La Cloche from the late 1920s on and recorded it in its many different moods. Here the land wears autumn colours on its sculptured surface. Rifts in the clouds provide the lit areas on the surface; the effect is one of Canadian grandeur at its height.

Franklin Carmichael
Oil on board, 96.5 x 122.0 cm
McMichael Canadian Art Collection, Kleinburg (1980.17)
Anonymous Donor

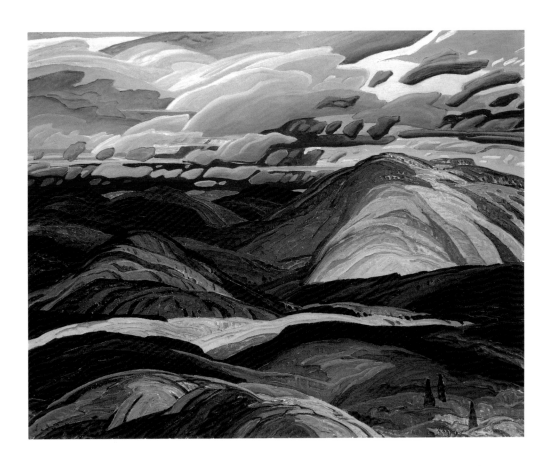

JACK PINE, 1942

Carmichael's zest for the medium of watercolour helped him depict the complex interaction of hills, stunted trees, and weather in his favourite painting place of the La Cloche. In the distance, note the way in which the forms of the hills are veiled in cloud, a visual image that suggests the immensity of the area. In the end, Carmichael's subject is his total visual experience of the scene.

Franklin Carmichael
Watercolour and charcoal on paper, 28.9 x 34.0 cm
Winnipeg Art Gallery (L-10)
Gift of J.B. Richardson and Wm. G. Rait

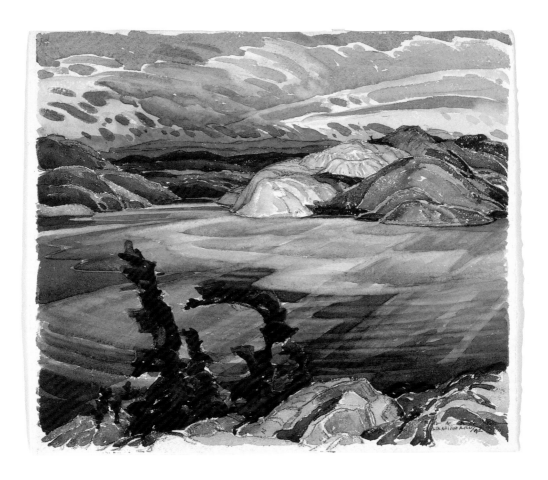

A.J. Casson, 1898–1992

Rock and Sky, 1921

Even before he was made a member of the Group of Seven (in 1926), Casson showed an interest in the great themes of the Group, here a single tree against the sky, which seems to grow directly out of the rock.

A.J. Casson
Oil on paperboard, 23.7 x 28.7 cm
McMichael Canadian Art Collection, Kleinburg (1966.16.127)
Gift of the Founders, Robert and Signe McMichael, Kleinburg, 1966

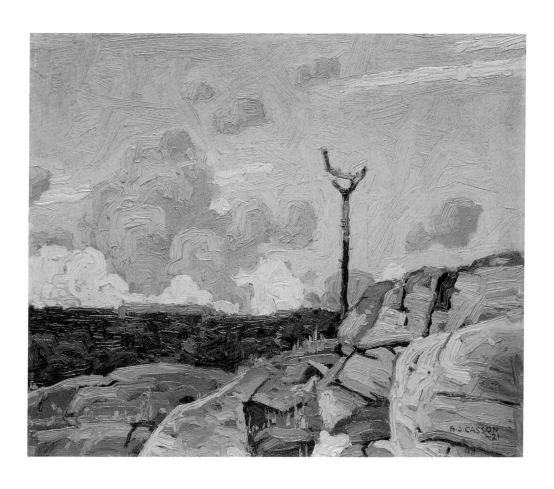

Lawren Harris, 1885–1970

Rocky Cliffs, Algoma, 1922

Lawren Harris first travelled to Algoma in May 1918 to recover from a nervous breakdown. Once he discovered the beauty of the place, he organized trips for himself and his friends and arranged to use a boxcar on the Algoma Central Railway, fitted up with bunks, sink, and stove, since there was no accommodation in the area. Though he loved the rugged wild land packed with an amazing variety of subjects, as he wrote, he felt uneasy with the area, as though he had come to a home too lavish for his taste. Nonetheless, Algoma, he could see, was a country that afforded a broad, rich treatment, one that combined the idea of wilderness and virgin nature with vast resource potential.

Lawren Harris
Oil on canvas, 122.6 x 153.0 cm
Art Gallery of Ontario, Toronto (69/123)
Bequest of Charles S. Band, Toronto, 1970

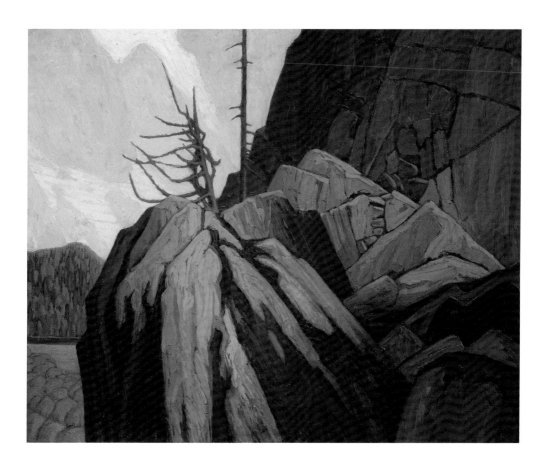

Sand Lake, Algoma, 1922

Sand Lake, Algoma was developed from a sketch of that name that Harris painted in Algoma. In the final work, he stressed the way light on the rocks at left approximates the rich iridescent colour on the wing of a moth or butterfly.

Lawren Harris

Oil on canvas, 82.3 x 102.0 cm

McMichael Canadian Art Collection, Kleinburg (1966.16.87)

Gift of the Founders, Robert and Signe McMichael, Kleinburg, 1966

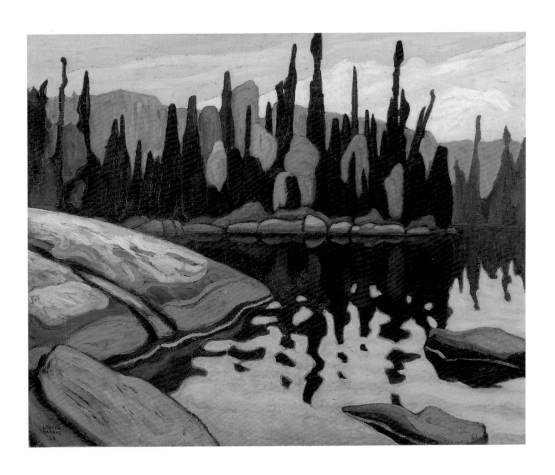

Mount Robson, c.1929

"Back of Jasper and at Mount Robson we were afraid of grizzlies…,"
Harris once wrote, but in his painting *Mount Robson*, of a mountain in
Jasper National Park, which he visited on his trips to the Canadian Rockies
in the later part of the 1920s, there is no trace of this concern. Harris con-
sidered this painting so important that he never sold it, but gave it to his son
Howard K. Harris, from whose estate it was purchased by the McMichael
Canadian Art Collection. The work shows Harris on the move towards
abstraction – summarizing, clarifying forms that recall the shapes in metal
or wood of the Art Deco style of the period. In this picture, by contrast
with other works of much the same time, he stressed the three-dimensional
quality of the forms.

Lawren Harris
Oil on canvas, 128.3 x 152.4 cm
McMichael Canadian Art Collection, Kleinburg (1979.20)
Purchased, 1979

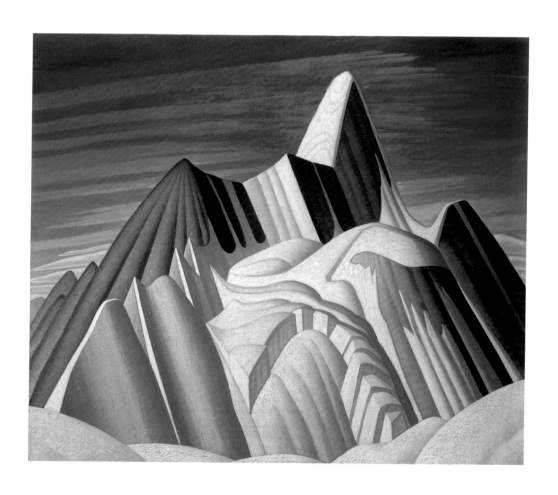

MT. LEFROY, 1930

In 1930, when Lawren Harris painted his major canvas of Mount Lefroy, he had been a full-fledged theosophist for almost a decade (he formally joined the Toronto Theosophical Society in 1924). In painting Mount Lefroy, a mountain located in Banff National Park that he would have seen on one of his visits to the Canadian Rockies from 1924 to 1928, he saw a way to convey a subtle lesson about nature and the supernatural rolled into one. As Charles C. Hill has written in *The Group of Seven: Art for a Nation* (1995), the mountain evokes a spiritual aura, like praying hands reaching to heaven. The cloud in the background, and the sense of quiet serenity, add to the subject: here Harris painted a universal form to represent things of the spirit.

It is interesting to speculate on Harris's creative evolution in composing this major canvas. Normally, a painter like Harris began with a pencil drawing, followed by oil studies, then the final work. In the McMichael Canadian Art Collection, there are several oil studies for the painting. Harris may have developed two of his simplified sketches in oil before drawing in pencil the sketch that became the basis of the oil sketch that he developed into the canvas, or perhaps all three oil studies came first, then the pencil sketch, which is squared off for transfer to canvas, and therefore may be the last step before the finished work. Certainly, as he worked, Harris exerted his shaping imagination; he edited his work to emphasize the vertical qualities of the mountain, the flowing lines to its subsidiary peaks, and the radiant shapes that surround the cloud in the background. He meant to create a new type of image that was meant to both calm and through its way of nudging Canadian art in a new direction, unsettle. His source was Cubism, the twentieth century's most influential style.

Lawren Harris
Oil on canvas, 133.5 x 153.5 cm
McMichael Canadian Art Collection, Kleinburg (1975.7)
Purchased, 1975

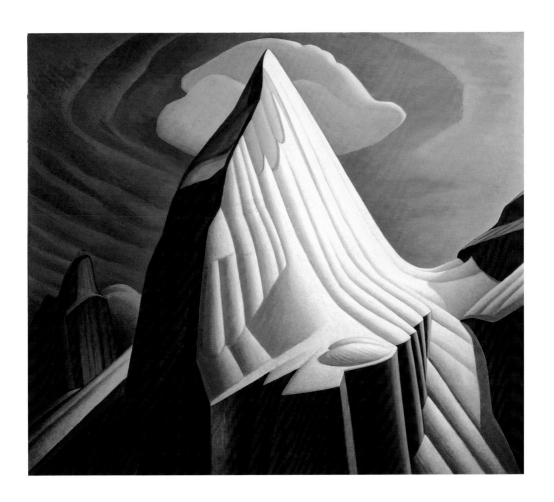

MOUNT LEFROY, C.1925

Because of the shape of the cloud in the background and the contours of the mountains, this panel is a candidate for the one closest in date to the origins of Harris's great painting (p.59).

Lawren Harris
Oil on wood panel, 30.2 x 37.5 cm
McMichael Canadian Art Collection, Kleinburg (1986.1)
Purchased, 1986

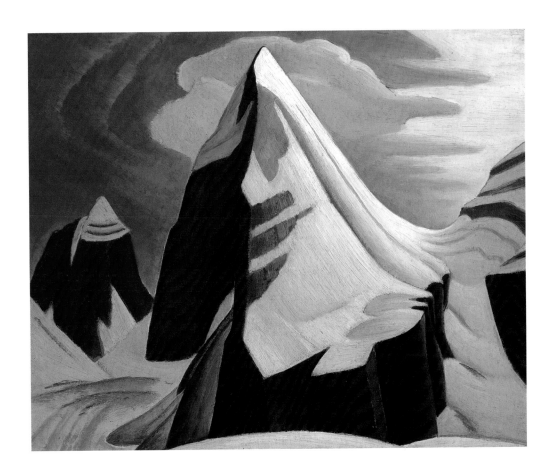

Mt. Lefroy, c.1929

In this sketch, Harris analysed the shape to Mt. Lefroy, bringing it closer to his final conception.

Lawren Harris

Oil on wood panel, 30.5 x 38.1 cm

McMichael Canadian Art Collection, Kleinburg (1981.85.2)

Purchased, 1973

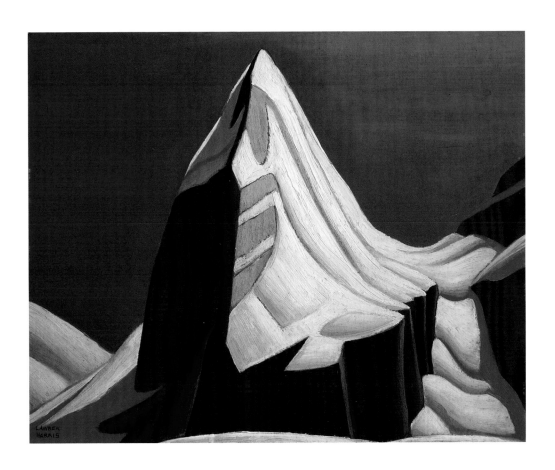

Rocky Mountain Sketch, Mt. Lefroy, c.1929

Here, Harris continued to develop the shapes of the mountains, summarizing and condensing the information he found in the sketch on p. 61. Notice that he has begun to focus on the "finger" shapes on the side of the mountain.

Lawren Harris
Oil on wood panel, 30.5 x 38.1 cm
McMichael Canadian Art Collection, Kleinburg (1971.12)
Gift of R.G. Colgrove, Don Mills, 1971

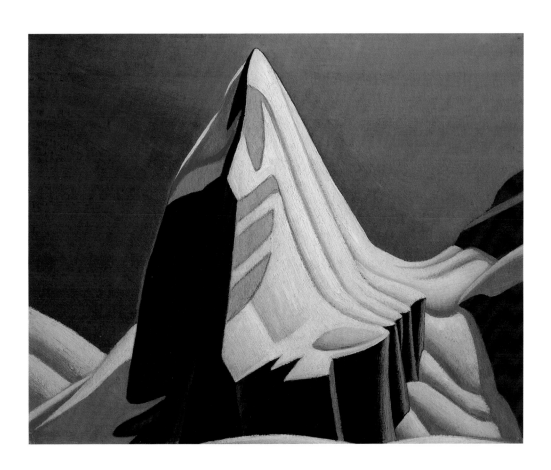

A.Y. Jackson, 1882–1974

Terre Sauvage, 1913

A.Y. Jackson painted the sketches for *Terre Sauvage*, the first large canvas of the new movement, from his trips paddling around the islands and exploring intricate channels and bays in Georgian Bay. In Toronto, Lawren Harris lent Jackson his studio at Bloor and Yonge Streets to develop the sketches into this great canvas. Jackson recalled in his autobiography later that J.E.H. MacDonald called the painting Mount Ararat because he thought it looked like the first land that appeared after the Flood subsided. It was when Jackson was painting this canvas that he first met Tom Thomson. Dr. MacCallum, patron and friend of the nascent Group of Seven, introduced them.

A.Y. Jackson
Oil on canvas, 128.8 x 154.4 cm
National Gallery of Canada, Ottawa (4351)
Purchased from the artist, Toronto, 1936

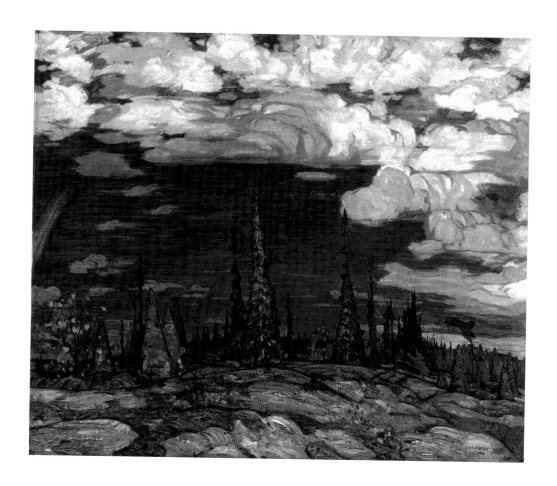

Night, Pine Island, 1924

The trees on this Pine Island, Georgian Bay, were painted many different times by Jackson – and Tom Thomson.

A.Y. Jackson

Oil on canvas, 64.2 x 81.5 cm

National Gallery of Canada, Ottawa (18124)

Bequest of Dorothy Lampman McCurry, 1974, in memory of her husband

Harry Oorr McCurry, Director of the National Gallery of Canada, 1939–55

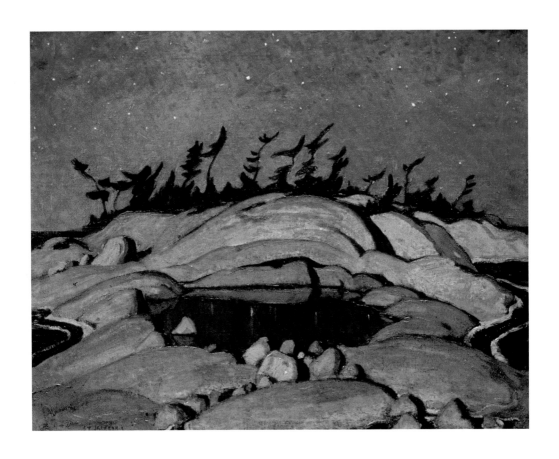

Hills, Killarney, Ontario (Nellie Lake), c.1933

Nellie Lake in Killarney Provincial Park lies in the northeast corner of
Georgian Bay. In his autobiography, *A Painter's Country*, Jackson recalled
the big hills that surround Nellie Lake, which is itself quite narrow. In this
painting, Jackson records his impression: the lake forms a small central
section of the picture, which is dominated by rolling hills and ancient rock.

A.Y. Jackson

Oil on canvas, 77.3 x 81.7 cm

McMichael Canadian Art Collection, Kleinburg (1968.8.28)

Gift of S. Walter Stewart, Toronto, 1968

Courtesy of the Estate of the late Dr. Naomi Jackson Groves

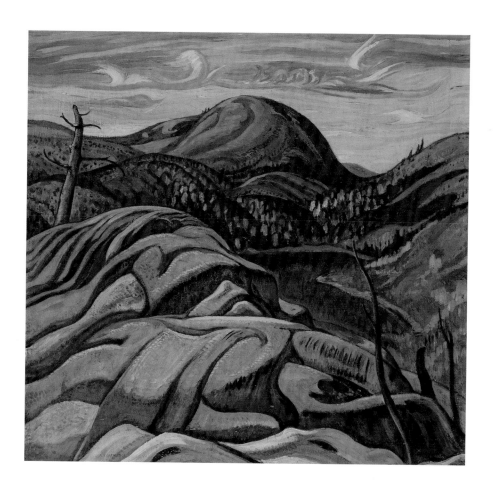

Precambrian Hills, 1939

Some of Jackson's liveliest paintings are of the rock and hills of the landscape. In trying his hand at what was a familiar subject to the Group of Seven, Jackson's version grabs the attention immediately and holds it. He was adept at conveying the shapes of the rocks and paring extraneous details from their forms. A seemingly simple, very small, yet striking detail is the grass that grows in the crevices in the foreground and lends authenticity to the scene.

A.Y. Jackson
Oil on canvas, 71.5 x 91.4 cm
Art Gallery of Ontario, Toronto (2829)
Purchase, 1946

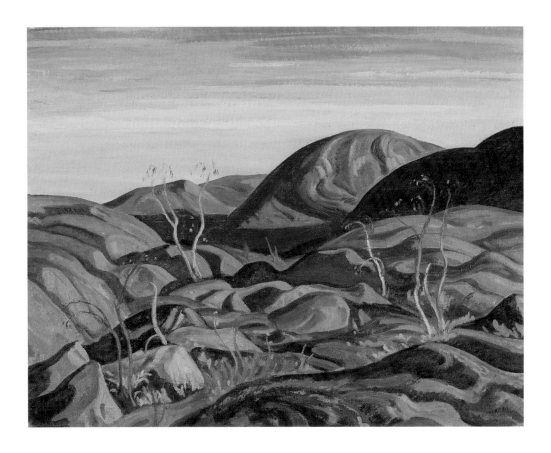

Hills at Great Bear Lake, c.1953

In his scenes of rock, Jackson conjured up a whole world of quiet, unpretentious landscape. He was also able to convey the immensity of the scene before him.

A.Y. Jackson
Oil on canvas, 96.5 x 127.6 cm
Art Gallery of Hamilton (58.74.X)
Gift of the Women's Committee, 1958

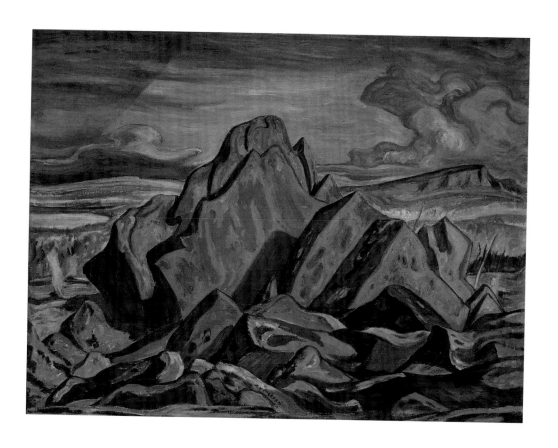

Frank (Franz) H. Johnston, 1888–1949

Where the Eagles Soar, c. 1920

Awesome to behold with its majestic height, weathered rockface, and evocation of grandeur, the mountain Frank Johnston paints looms large in the story of rocks and the Group of Seven. Scenes like this set the tone for the Group.

Frank (Franz) H. Johnston
Oil on canvas , 101.6 x 81.2 cm
Art Gallery of Ontario, Toronto (134)
Gift of the Canadian National Exhibition Association, Toronto, 1965

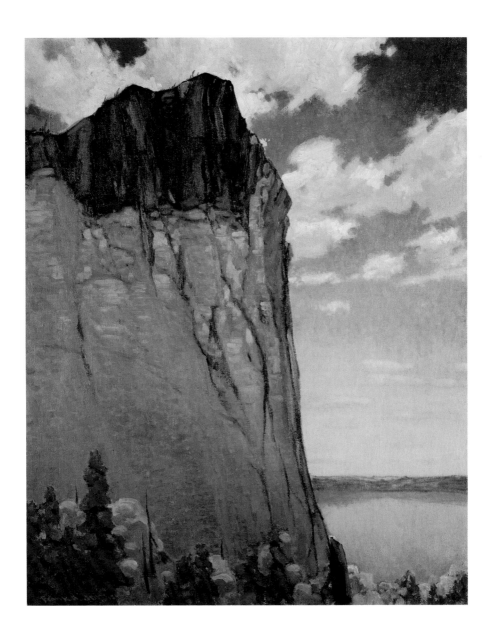

Arthur Lismer, 1885–1969

Sketch for "Rock, Pine and Sunlight" (1), 1921

Lismer believed that Canada with its distinctive seasons and rugged landscape had to be depicted with bold and massive design. Comparison of one of the sketches for the canvas of *Rock, Pine and Sunlight* shows the way he worked from nature but emphasized emphatic design and brushwork.

Arthur Lismer
Oil on panel, 29.8 x 40.7 cm
Art Gallery of Ontario, Toronto (70/332)
Gift of Arthur Lismer, 1940

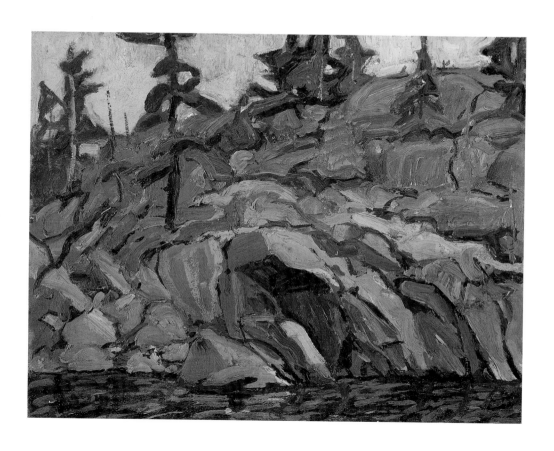

Rock, Pine and Sunlight, 1920

In the final painting of *Rock, Pine and Sunlight*, Lismer documented several key features of Canadian nature. His sketch of the rockface on p. 79 is proof that there was nothing haphazard about his carefully thought-through and felt-through art.

Arthur Lismer

Oil on canvas, 91.4 x 111.8 cm

Art Gallery of Ontario, Toronto (1334)

Purchase, 1929

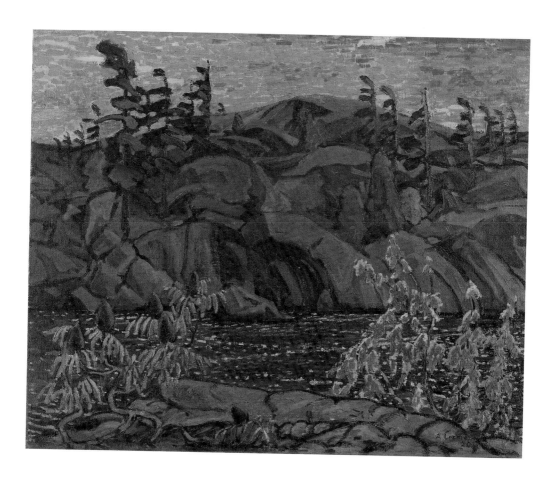

The Big Rock, Bon Echo, 1922

The imposing geological feature of Mazinaw Rock on Lake Mazinaw northeast of Peterborough in Eastern Ontario, depicted here by Lismer, is today part of Bon Echo Provincial Park. The Rock is the result of a fault in the earth's surface. Artists and writers were attracted to Bon Echo during the 1920s because of Merrill Denison, a well-known playwright and broadcaster, who during these years operated Bon Echo Inn.

In painting the rock, Lismer emphasized the vertical element to suggest what he sensed in the rock – a powerful spiritual presence. For Lismer, the subject of rock had the quality of a cathedral without walls.

Note the firmly painted bravura effect Lismer achieved when painting the low water level: he used gold strokes of paint at the base of the rock, seemingly dashed on. The shadow on the rocks is equally boldly indicated with confident strokes of (here, dark) colour.

Arthur Lismer
Oil on canvas, 91.6 x 101.7 cm
National Gallery of Canada, Ottawa (2004)
Purchased, 1922

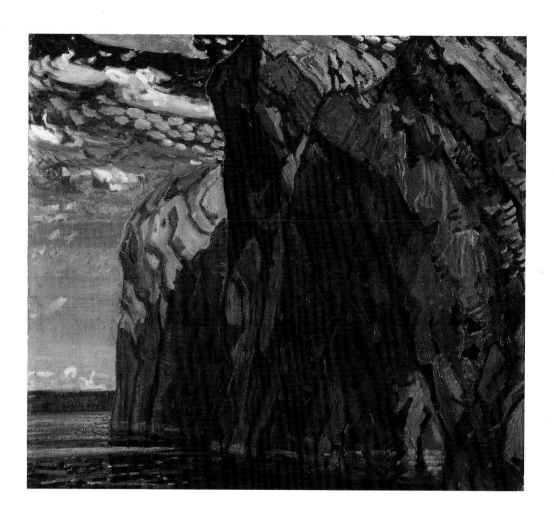

THE GLACIER, 1928

Lismer used strong design and the simplification provided by the style of Cubism to turn the complex planes in the spaces of rock into transporting life. The flowing snow of this glacier has an exuberance characteristic of the artist himself.

Arthur Lismer

Oil on canvas, 101.5 x 126.7 cm

Art Gallery of Hamilton (60.77.J)

Gift from the Women's Committee, 1960

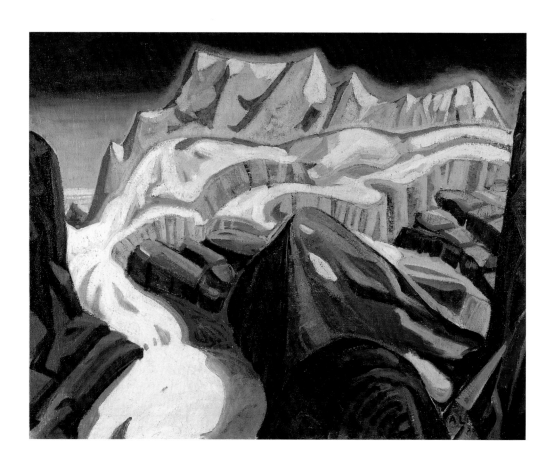

Cathedral Mountain, 1928

In *Cathedral Mountain*, which Lismer painted in a boldly expressionistic style characterized by energetic brushwork, simplified form, and strong design, the mountain has echoes, as he intended, of a Gothic structure. Lismer told Dr. Evan Turner, of the Montreal Museum of Fine Arts, that when he saw the mountain, he was struck by "the buttresses and the pillars, towers and supporting weights" (see the Appendix for more of the interview). "It looked like a vast piece of architecture," Lismer continued, comparing the mountain to the architecture and spiritual nature of a church. The people responsible for the names Temple Mountain, Castle Mountain, Cathedral Mountain, he believed, were reminded of something in the edifices of the Church throughout history. He painted it that way, more vertical than it is in reality, with its tops touching the clouds. For him, Cathedral Mountain was an "almighty paean of praise."

Arthur Lismer
Oil on canvas, 121.9 x 142.2 cm
Montreal Museum of Fine Arts (1959.1219)
Gift of the A. Sidney Dawes Fund

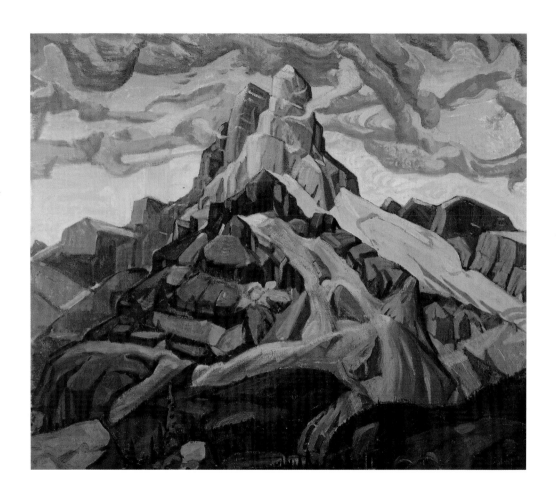

J.E.H. MacDonald, 1873–1932

Autumn Colours (Rock and Maple), 1916

On the verso is the inscription "Rock and Maple / Georgian Bay / in the narrows / made from the boat." The subject is the Moon River at the Narrows, in Go Home Bay, Georgian Bay.

J.E.H. MacDonald
Oil on cardboard, 53.4 x 66.2 cm
National Gallery of Canada, Ottawa (15494)
Vincent Massey Bequest, 1968

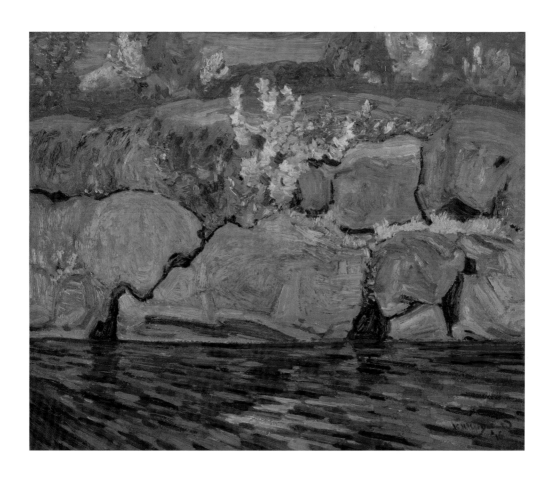

Dark Autumn, Rocky Mountains, 1930

In the process of painting mountains, MacDonald transformed them into works that are as much a tribute to the power of paint and strong design as to their rocky shapes.

J.E.H. MacDonald
Oil on canvas, 53.7 x 66.3 cm
National Gallery of Canada, Ottawa (4875)
Purchased, 1948

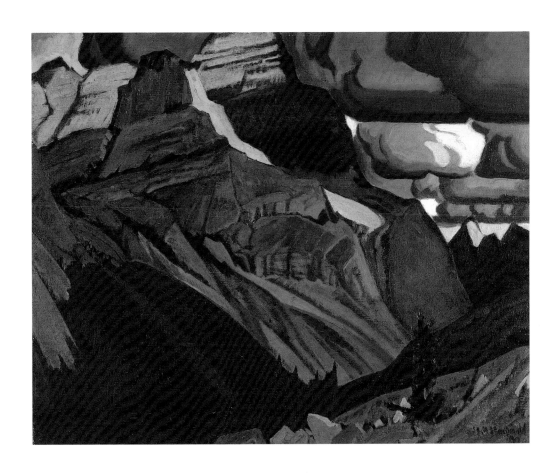

Tom Thomson, 1877–1917

The Birch Grove, Autumn, 1915–16

Tom Thomson indelibly recorded here his love of Algonquin Park, the site of this painting, and the way trees seem to spring from the rock itself. A comparison with the sketch for the canvas *Birches* in the National Gallery of Canada shows that Thomson exaggerated the hillside to give the picture greater depth. He also applied bold, summary strokes to create the rock shapes. At a distance, the strokes mesh for powerful effect.

Tom Thomson
Oil on canvas, 99.0 x 115.4 cm
Art Gallery of Hamilton (67.112.2)
Gift of Roy G. Cole, in memory of his parents
Matthew and Annie Bell Gilmore Cole, 1967

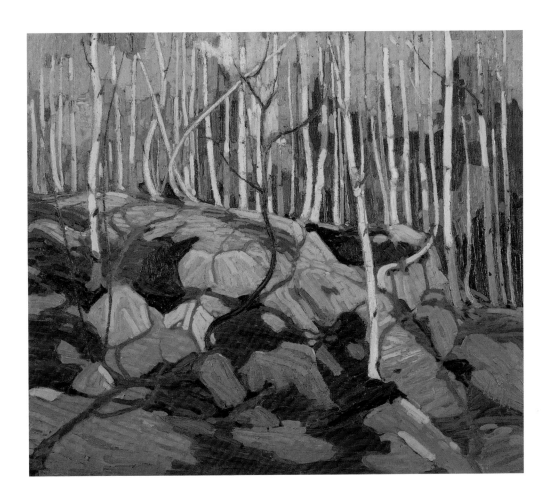

PINE CLEFT ROCKS, 1916

One of Thomson's intriguing works is this small painting with its colour medley: the rocks are yellow and flesh-coloured with blue edges, the trees have purple shadows and these effects harmonize with the red leaves of the trees and yellow patches on the ground.

Tom Thomson
Oil on wood panel, 21.4 x 26.8 cm
McMichael Canadian Art Collection, Kleinburg (1971.11)
Gift of Canada Trust, Toronto, 1971

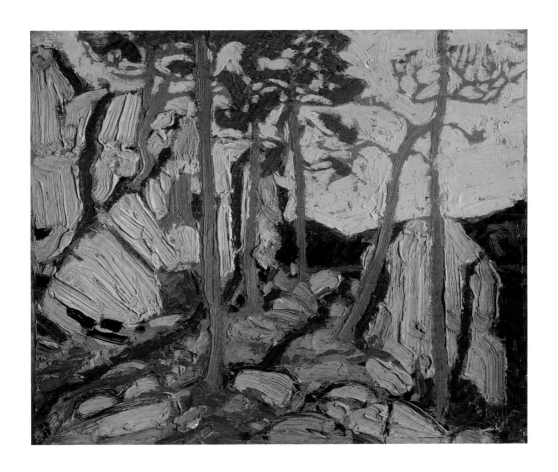

Spring Lake, 1916

Thomson tried to convey the texture of the rock using heavy impasto, documenting its rough surface diligently. He simplified details, exaggerated colours and contrasts of light and dark, and pushed monumental elements like the rock into the foreground to create an energetically animated image.

Tom Thomson

Oil on composite wood-pulp board, 21.5 x 27.0 cm

Tom Thomson Memorial Art Gallery, Owen Sound (967.030)

Gift of the Lyceum Club and Women's Art Association of Owen Sound, 1967

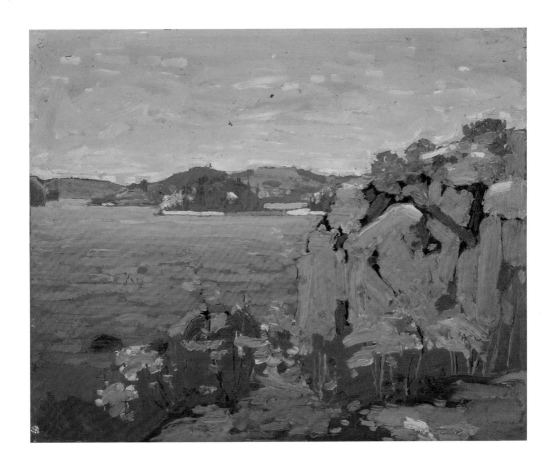

F.H. Varley, 1881–1969

Early Morning, Sphinx Mountain, c.1928

Varley was fascinated with the vast scale of the mountains of British Columbia, where he had moved in 1926. In 1927–28, he began to abstract mountain forms, pushing them into new shapes. At the same time, he worked with greater freedom in terms of colour, using paint more heavily in some areas to suggest texture. In this painting, the massive shape of an ice floe swirls diagonally down the left side of the canvas by contrast with a more angular rocky mountainside to the right. The colour is exotic and high-keyed (pink and turquoise combined in an ethereal mixture), as the mountain is touched by the light of the rising sun.

F.H. Varley
Oil on canvas, 119.4 x 139.8 cm
McMichael Canadian Art Collection, Kleinburg (1972.11)
Purchased, 1972
©Town of Markham, Varley Art Gallery

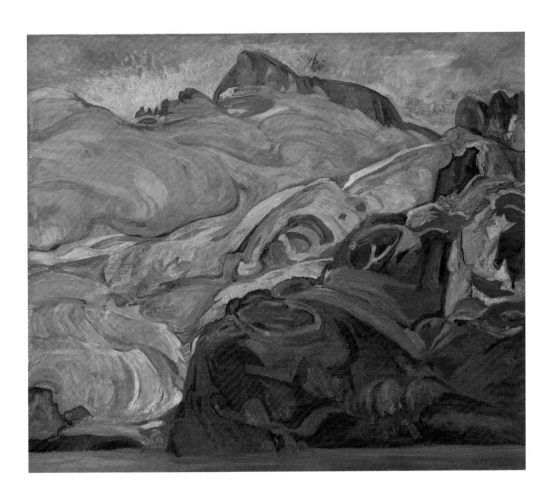

MIMULUS, MIST AND SNOW, 1927–28

The interplay of mountain and forms of vegetation (the mimulus are small mountain flowers) interested Varley, and in painting them he generalized and abstracted. Here, the tumbling rhythm of the rock approaches abstraction.

F.H. Varley

Oil on canvas, 69.6 x 69.6 cm

Museum London, London, Ontario (72-A.117)

Gift of the Volunteer Committee and Mr. and Mrs. Richard Ivey, London, Ontario, 1972

©Town of Markham, Varley Art Gallery

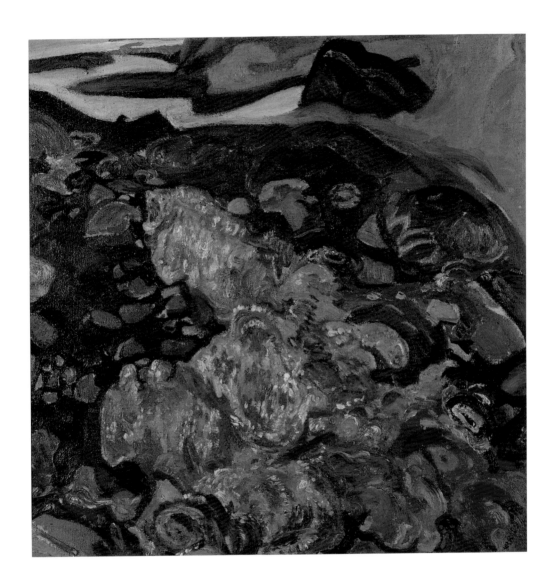

Appendix

Interview with Dr. Arthur Lismer by Dr. Evan H. Turner, Montreal Museum of Fine Arts, n.d. (1977?), Library and Archives Canada, Gatineau, J. Russell Harper fonds, volume 28, file 19.

✦✦✦

As I recall it, Harris was over the hill – that's Lawren Harris, at Lake Louise, and he and I joined forces for this particular trip. MacDonald was somewhere around Lake O'Hara.

I don't know what the mountains do to you actually. They offer a challenge. We'd been painting in Georgian Bay and Algonquin Park where all the horizons were straight and the trees stuck up and I suppose in the first days of the Group there was a more ... a sort of conventional pattern that crept into the work but it was either spruce trees, or forest sticking above the horizon, but this Cathedral Mountain, to me, it was like a great big Gothic structure. It was an amazing thing. We were up about 6 or 7,000 feet, I suppose, and from every angle and in a vast territory like this you had to stalk your prey, as it were, to find a way of getting at it. The thing struck me – it was remarkably Gothic – there were the buttresses and the pillars, towers and supporting weights like a vast piece of architecture ... the first ways of looking at these things, we were looking for the design of the idea. I recall that most of the people in the Group of Seven, except MacDonald, never looked at their foregrounds. They looked right at the distance and I suppose this is a kind of adoration, that you can look up and find glory – the clouds coming to it, you see, as well as the structure of the whole composition. But it was called

Cathedral and I suppose originally, when these places were named, there was Temple Mountain, Castle Mountain, Cathedral Mountain. Always, I think in the original, people who are responsible for the naming of these peaks, I had an idea that they were reminded of something in the edifices of the Church in history.

However, making the sketch was not difficult. It was comfortable enough in that clear air. And there's another thing – the atmosphere of the upper regions there. To approach it you passed through mountain Alpine meadows bestrewn with flowers and you were looking down on little lakes. You had a feeling of omniscience about the place and then looking up to the top of this mountain. Well, the idea was to reduce these forms away from the usual topographical photographs that you see in brochures and go on and try and get some kind of design out of it.

And you began to … see a rhythm that united sky and land in a great rhythm, and it was challenging. When you got back to your studio as a matter of composing it into, well, composing yourself and it into some kind of canvas that brought out those particular attributes. Another thing about that feeling, we were all ambitious for covering large surfaces … you can't reproduce a mountain on a small sketch and size, not just of style, but the actual area of the canvas covered was a challenge.

Cathedral Mountain is a memory. Looking down at little green, and they were green, lakes surrounded by the spruce and pine and looking up and seeing this thing soaring into the clouds which took up the rhythm and fetched it into an almighty paean of praise and you felt a very small unit in the matter … other artists have painted this … Harris painted one from the other side and MacDonald painted it from the distance. You see, these peaks are never hidden …

❖❖❖

I don't think this mountain period lasted a very long time. I never cared for it a great deal. There was nothing very intimate about it. There were no foregrounds. You were always looking into middle distances and distances. I still think the Georgian Bay, or some other topographical curiosity in Canada is much more attractive. Mountains don't bend in the wind and they don't offer any response to the elements. A few clouds come over the top of it. For days you have to wait for a clear sky. But they were a little cold and forbidding. I was glad to get back to a foreground and a tree and a few shadows.

SELECTED BIBLIOGRAPHY

Bice, Megan. *Light & Shadow: The Work of Franklin Carmichael.* Kleinburg: McMichael Canadian Art Collection, 1990.

Bridges, Marjorie Lismer. *A Border of Beauty: Arthur Lismer's Pen and Pencil.* Toronto: Red Rock, 1977.

Darroch, Lois. *Bright Land: A Warm Look at Arthur Lismer.* Toronto/Vancouver: Merritt Publishing Company Limited, 1981.

Hill, Charles C. *The Group of Seven: Art for a Nation.* Ottawa and Toronto: National Gallery of Canada and McClelland & Stewart, 1995.

Mastin, Catharine M. *Portrait of a Spiritualist: Franklin Carmichael and the National Gallery of Canada Collection.* Ottawa: National Gallery of Canada, 2001.

Robertson, John K.B. "Canadian Geography and Canadian Painting," *Canadian Geographical Journal* 39, no. 6 (December 1949), 262–73.

Stacey, Robert, and Stan McMullin. *Massanoga: The Art of Bon Echo.* Toronto: Archives of Canadian Art, 1998.

Illustration Credits

Art Gallery of Hamilton 75, 85, 93

Art Gallery of Ontario, Toronto 5 (Sean Weaver), 37, 53, 73, 77, 79, 81

Firestone Art Collection, The Ottawa Art Gallery 39 (Tim Wickens)

Hart House, University of Toronto 35

McMichael Canadian Art Collection, Kleinburg VIII (Joachim Gauthier), 3, 4, 6, 15, 22, 41, 43, 47, 51, 55, 57, 59, 61, 63, 65, 71, 95, 99

Montreal Museum of Fine Arts 87 (Denis Farley)

Museum London 19, 101

National Gallery of Canada, Ottawa 9, 12 (M.O. Hammond), 14, 16, 20, 24, 31, 33, 45, 67, 69, 83, 89, 91

Tom Thomson Memorial Art Gallery, Owen Sound 97

Winnipeg Art Gallery 49

ACKNOWLEDGEMENTS

In preparing this text, I would like to thank the following individuals and public galleries for their help with information: Georgiana Uhlyarik and Catherine Spence of the Art Gallery of Ontario, Toronto; Tobi Bruce of the Art Gallery of Hamilton; Catharine Mastin of the Glenbow Museum, Calgary; Geneviève Morin of the Library and Archives Canada, Gatineau; Janine Butler and Linda Morita of the McMichael Canadian Art Collection, Kleinburg; Janette Cousins Ewan of the Museum London, London, Ontario; Sharon Odell and Shawn Boisvert of the National Gallery of Canada, Ottawa, and Mary Jo Hughes, who kindly looked over the work of LeMoine FitzGerald for me at the Winnipeg Art Gallery.

The main text is set in Monotype Fournier. It is a Transitional, or Neo-Classical typeface, originally
designed c. 1740 by Pierre Simon Fournier, Paris. It was recut and released in 1926 by Monotype,
England. The credits are set in FFMeta, designed 1985–91 by Erik Spiekerman, Berlin.

Separations by Emersom Group

Printed by Friesens Printers.